FLW 107

⌗ AS A MATERIAL WE MAY REGARD
IT AS A CRYSTAL-THIN SHEET
OF AIR IN AIR TO KEEP AIR
OUT OR KEEP IT IN. AND WITH
THIS SENSE OF IT, WE CAN
THINK OF USES TO WHICH IT
MIGHT BE PUT AS VARIOUS
AND BEAUTIFUL AS THE FROST
DESIGNS UPON THE PANE OF
GLASS ITSELF. ⌗

— FRANK LLOYD WRIGHT
ARCHITECTURAL RECORD, 1928

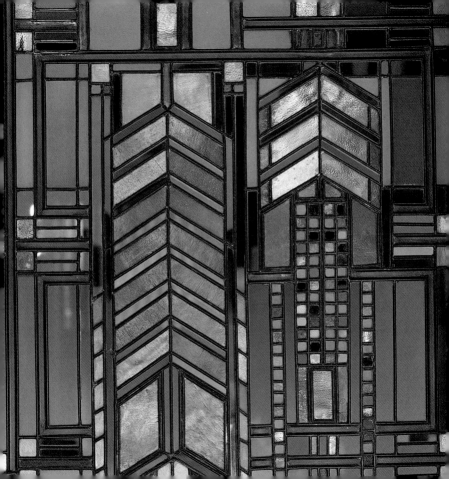

FRANK LLOYD WRIGHT'S
GLASS DESIGNS

▦ CARLA LIND ▦

AN ARCHETYPE PRESS BOOK

POMEGRANATE ARTBOOKS, SAN FRANCISCO

Library of Congress Cataloging-in-Publication Data

Lind, Carla.

Frank Lloyd Wright's glass designs / Carla Lind.

p. cm. — (Wright at a glance)

"An Archetype Press book."

Includes bibliographical references.

ISBN 0-87654-468-5

1. Wright, Frank Lloyd, 1867–1959 — Criticism and interpretation. 2. Glass art — United States. 3. Decoration and ornament, Architectural — United States. 4. Glass painting and staining — United States. 5. Glass construction— United States. I. Title. II. Series: Lind, Carla. Wright at a glance.

NK5398.W78L56 1995 95-417

748.5913—dc20 CIP

Published by

Pomegranate Artbooks

Box 6099, Rohnert Park,

California 94927-6099

Catalogue no. A796

Produced by Archetype Press, Inc.

Washington, D.C.

Project Director: Diane Maddex

Editorial Assistants:

Gretchen Smith Mui, Kristi Flis,

and Christina Hamme

Art Director: Robert L. Wiser

10 9 8 7 6 5 4 3 2 1

Printed in Singapore

Opening photographs: Page 1: Frank Lloyd Wright about 1920. Page 2: Art glass in a doorway, Dana-Thomas house (1902), Springfield, Illinois. Pages 6–7: Arched window in the Dana-Thomas gallery.

CONTENTS

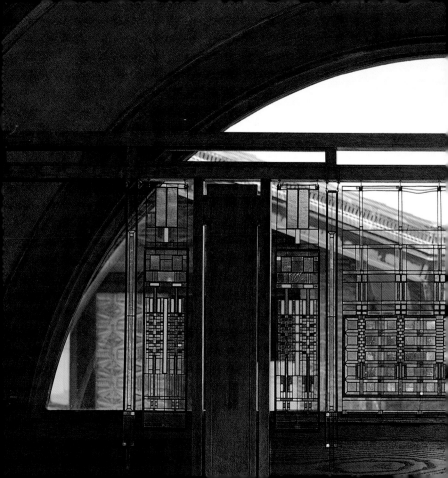

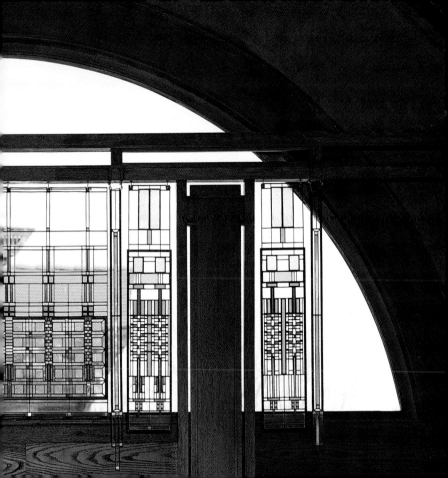

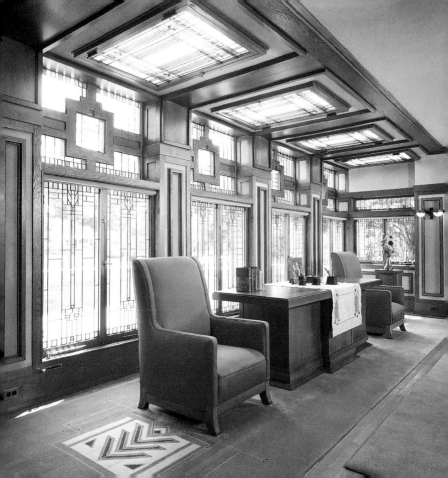

THE MECHANIZATION OF THE GLASS industry and the onset of Frank Lloyd Wright's career occurred simultaneously. Growing together, each was enhanced by the other. Until 1883, when the first successful American plate glass plant was built, window glass was imported from France and Germany. By the 1920s new flat sheet methods had revolutionized the industry, increasing production tenfold.

Wright (1867–1959) embraced glass, studied it, experimented with it, paid tribute to it, and used it extensively. Fitting perfectly into his philosophy of organic architecture, it was an ideal partner in his quest to open up living spaces to suit the informality of the American lifestyle. Glass permitted interaction with the outdoors while protecting one from the elements. In 1928 as part of his "In the Cause of Architecture" series for *Architectural Record,* Wright even wrote an essay on glass, likening it to nature's mirrors—the water in ponds, lakes, and rivers.

One of Wright's earliest techniques for breaking out of the boxlike houses of the time was to use more glass and to string together windows in bands to create

Wright combined skylights with fixed and casement windows of art glass to create a golden solarium corner in the living room of the May house (1908), a Prairie gem in Grand Rapids, Michigan.

At the Darwin Martin house (1904), Buffalo, New York, iridescent glass in the three blooming stalks of the Tree of Life window changed color as the light changed.

screens of light adjoining the solid screens of walls. This continuous fenestration served both to dissolve the resistance of the wall and to reinforce the horizontality of his buildings. The lightness and the fragility of glass were a counterpoint to the heaviness and solidity of stone, brick, concrete, and wood. Wright liked placing glass where one expected solid structure, such as at corners and ceilings.

He fought for casement windows over double-hung windows because they opened more naturally to the outdoors, inviting nature to become part of the interior spaces. Ribbons of windows were used vertically as well as horizontally to release spaces and welcome sunlight. He patented several glass innovations, and as the years progressed he included more walls of glass, further reducing the visual barrier between inside and outside.

Wright is most well known for his art glass designs from the first two decades of his seventy-year career. The geometric designs for his Prairie Style houses represent some of the most spectacular integral ornament of his lifetime. His interpretation simplified this old art form and made it an intrinsic component of his architecture.

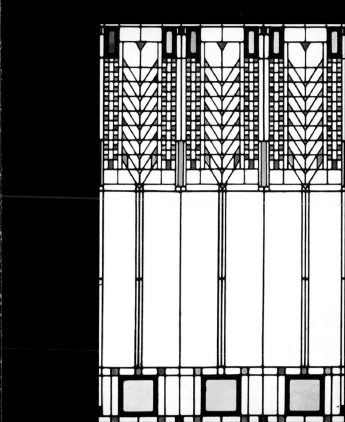

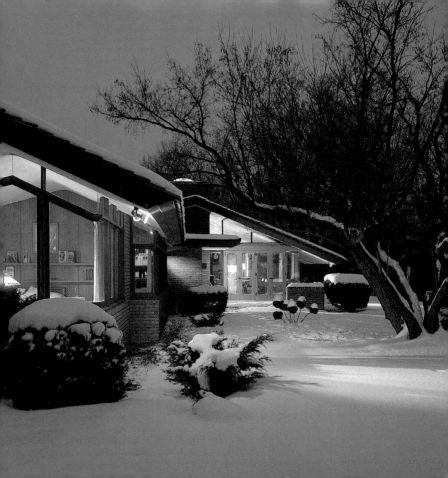

Glass walls in the Schaberg house (1950), Okemos, Michigan (opposite), invite nature in. The entry laylight of the Roberts house (1896) in Oak Park used the leading as part of the design.

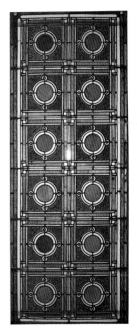

Characteristically, Wright could not just accept traditional uses of glass but had to discover new ones for himself. He carefully selected from a range of old and new products to get the effects he desired. But in each application of the material—whether in art glass, set in concrete blocks, or as glass tubing, glass vases, or glass walls—the geometry of the design was based on the same Froebel fundamentals he learned as a child. Using blocks and cardboard shapes manipulated on a grid surface, these kindergarten exercises taught him about the relationship between botany and geometry. Such lessons for designing permeated his work from plan to detail.

The path of Wright's career can be followed by observing how he wove glass into his designs. Beginning with intricate art glass windows in his early work and moving to various innovative techniques midcareer, then larger and larger units of glass in his later buildings, his designs became more open and informal. Throughout, Wright masterfully manipulated the material in countless ways, seeking to capitalize on its unique nature. For him, playing with glass was like playing with air and light themselves.

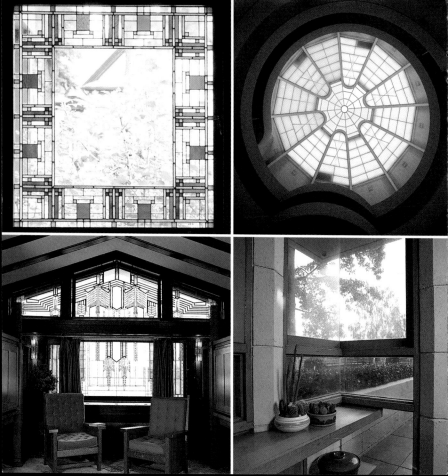

Nature brought inside

Integration with the outdoors, opening and framing views. A foil, surrounding and illuminating nature without competing with it

Manipulation of light

Color or texture added to glass, especially skylights and light fixtures, to diffuse and soften the effect of direct light

Open yet sheltering

An invisible barrier permitting clear vision as well as protection from the elements

Destruction of the box

A perfect tool to open up the boxiness of houses

Privacy screen

Light reflected off multipaned windows to create privacy without curtains

Integral ornament

Repetition of the prevailing grammar of a structure for a reasonable cost

Innovative uses

Invisible joints in plate glass, tubular glass, and prisms redirecting diffused light. Panes inserted into concrete and wood

Nature-based art glass

Motifs derived from nature, geometric forms, and the plan of a building itself

Luminous skylights

Space released while light added. Complex and colorful, with more abstract patterns

Autumnal colors

Golds, greens, touches of white and red used with generous amounts of clear glass

Malleability

Various thicknesses from one-eighth to one-half inch and many widths. Molded or blown into shapes, colored, cut, or textured

Durability

Fireproof, relatively strong, and suitable for use inside and outside a structure

Mass production

Increased availability and lower expense through use of machine technologies

Top: Looking out Wright's Oak Park office (1898) and the Guggenheim Museum (1954) skylight. Bottom: A sumac window at the Dana-Thomas house and an invisible corner joint in California.

FROM THE BEGINNING OF HIS CAREER in 1889 until the 1920s, Wright included leaded glass windows in his architectural palette. In contrast to elaborate designs for medieval churches and Victorian houses, Wright's glass was restrained and geometric and used clear glass effectively to frame views from each window.

Patterns related to the motifs of a building, as the veins in a leaf recall the structure of a tree. Pieces were set in metal channels called cames (or leading, after the most common material used). Wright preferred zinc, which was stronger, but he would often electroplate it or replace it with copper for its warm patina. The joints were soldered, and then the glass was puttied in place. Wright varied the dimensions of the cames as well as the glass shapes, using the metal screen as part of the pattern.

None of his art glass could have been accomplished without clever and sympathetic craftsmanship. Notable among Wright's glassmakers were Orlando Giannini of Giannini and Hilgart, Frank Linden of the Linden Glass Company, William Judson of the Judson Studios, and Temple Art Glass.

⊞ These prismatic designs capture and retain light, holding it within their sparkling geometrics, so that enclosure is perceived as lines woven in space. ⊞

Robert McCarter

In *Frank Lloyd Wright: A Primer on Architectural Principles*, 1991

Delicate glass offered an opportunity for variations on Wright's symphonic compositions. He favored opalescent, flashed, gold foil, and iridescent glass, particularly in golds and greens, like this doorway of the Dana-Thomas house (1902), Springfield, Illinois, with its stylized butterfly design.

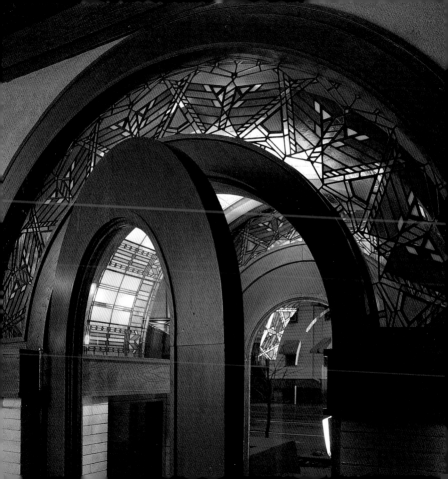

EARLY WORK

The lotus-shaped glass in the dining room of Wright's Oak Park home, added in 1895, reflected the era's common use of conventionalized natural forms.

⊞ Nothing is more annoying to me than any tendency of realism of form in window-glass, to get mixed up with the view outside. A window pattern should stay severely "put." ⊞
Frank Lloyd Wright
"In the Cause of Architecture,"
Architectural Record, 1928

THE PROGRESSION OF WRIGHT'S USE of art glass can be studied in just one building: his Home and Studio in Oak Park. The earliest part from 1889 had simple, clear, diamond-paned glass, a common component of Shingle Style and other Wright houses of the period. It effectively provided a sparkling privacy screen for the living spaces within.

When Wright designed his dining room addition in 1895, he again used leaded glass but adapted a design from a German pattern book. It was an Egyptian lotus motif, a bit more elaborate than the diamond panes but still simple. The designs for the new playroom and his own studio, added three years later, were more rectilinear, original, and colorful.

Wright's crystalline designs for the "bootleg" McArthur house (1892) in Chicago were for the built-in buffet and interior doors. He used cames of different dimensions and touches of green, gold, and white glass. The vertical designs appear to have been derived from a plant form—and look as if they grew from the frame base. They were clearly a departure from the designs of the time.

ſULLIVANEſQUE FORMſ

The stairhall of the Roberts house (opposite) included a delightful floral design of overlapping segments of circles, fanning out from the center of the huge arched window. The circular motif extended to the study windows nearby (above).

LOUIſ ſULLIVAN, WRIGHT'ſ INFLUENTIAL employer from 1888 to 1892, did not favor residences and used little art glass. But he taught Wright about integral ornament and how to use simple geometric forms derived from nature. The young Wright was certainly influenced by his mentor's design genius, particularly for terra cotta patterns in his early buildings. In a few of Wright's transitional commissions, Sullivan's influence could be seen in the glass designs as well.

For the Winslow house (1894) in River Forest, Wright used both pattern-book windows in a lotus pattern and distinctive curvilinear designs in the dining room bay windows. Simpler than the Sullivanesque design of the house's terra cotta frieze, they still were more the work of a compass than the T-square Wright used for later designs.

For the 1896 remodeling of the Charles Roberts house in Oak Park, the glass designs were simple, clear, and curvilinear. A flowerlike design in the stairhall was repeated in adjoining windows, creating a horizontal chain. The laylight over the entry hall was composed of rows of circles in shades of gray and gold (page 13).

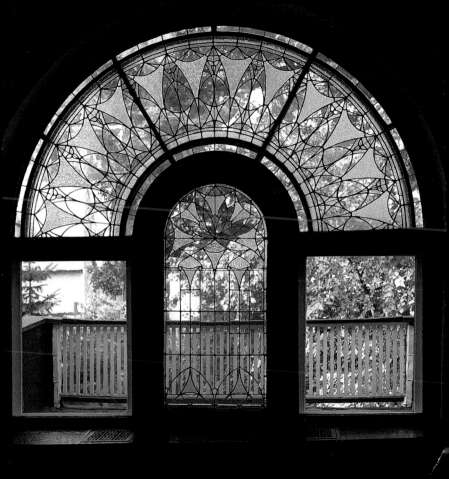

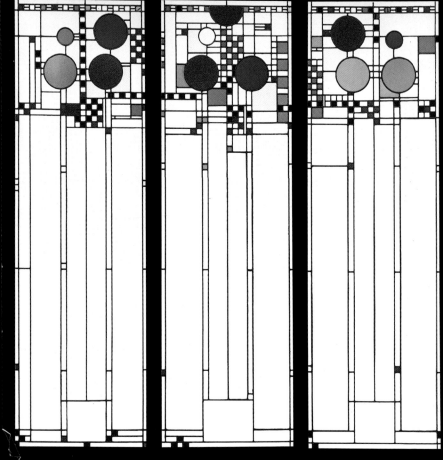

GEOMETRIC DESIGNS

LESSONS FROM CHILDHOOD, 1900-1923

BY 1900 WRIGHT HAD SOLIDIFIED his principles of organic architecture into the Prairie Style grammar. It included generous amounts of art glass windows with angular, geometric designs in an astounding variety: from exterior windows to skylights, cabinets, interior doors, and light fixtures. Most resulted from his skillful manipulation of his trusted T-square and triangle and were born from the floor plans, elevations, and other details of a building itself. The blocks, shapes, and table grids of his childhood training were transformed into rectilinear pieces of glass within a grid of metal cames.

One of the earliest examples is the Bradley house (1900), Kankakee, Illinois, whose distinctive gabled roof is echoed in the windows. Primarily clear glass—in response to the beauty of the wooded site—they are a screen that enhances the interior by joining it to the outside.

At the Willits house (1901), Highland Park, windows meet at corners and touch the roofline, releasing the enclosure. Only bits of white and golden glass accent the primarily clear panes. Glass helped Wright focus on the space within rather than the structure defining it.

Seemingly marching around the top of the room, the bold primary colors and abstract design of the windows of the Coonley playhouse (1912), Riverside, Illinois, resembled the paintings of Piet Mondrian a decade later. Using flashed opal glass, white outside and colored inside, the windows recalled the balloons, confetti, and flags of a parade.

⊞ [The Coonley playhouse windows are] luminous reminders of how he reversed the inward focus of medieval stained glass. ⊞
Rita Reif
New York Times, 1994

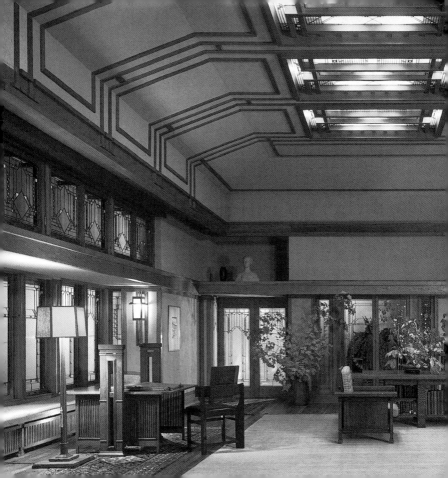

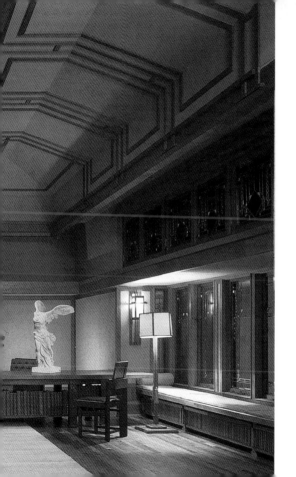

Wright's last windows designed for a Prairie Style house were for the Francis Littles' lakeside home, Northome (1912, demolished), outside Minneapolis. The living room windows, now in the Metropolitan Museum of Art, are notable for their simplicity, delicacy, and interlocked design. Their tiny triangles seem to twinkle like the surface of the lake and are concentrated on the borders to avoid competing with the waterfront view. The Littles objected to an earlier design that was more rectilinear and included more green glass.

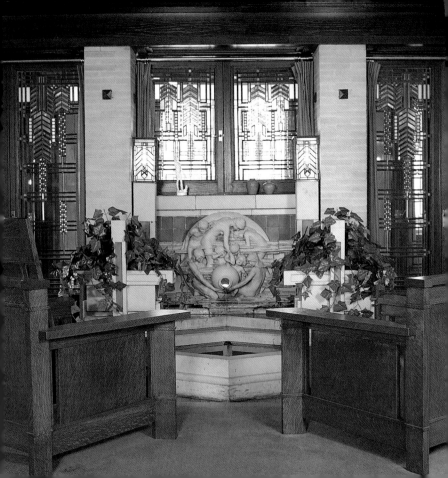

NATURE PATTERNS

Windows of the Robie house (1906), Chicago, combine angular forms with grain shafts.

Plant forms, autumn colors, and prairie shapes were captured in 450 custom glass panels fabricated for the Dana-Thomas house by Linden Glass.

WRIGHT'S EDUCATION FROM CHILDHOOD ON was steeped in theories about the relationship among nature, geometry, and design. Inspired by his Froebel education, he sought "the graphic soul of a thing." Popular architecture theorists of the nineteenth century from John Ruskin to Sullivan and the Arts and Crafts leaders looked to natural forms for ornament. Wright channeled all these rivers of thought into his own wellspring of designs.

Although all his glass patterns were geometrically based, some art glass included more recognizable abstract, botanical forms than others. The most obvious were the sumac windows for the Dana-Thomas house (1902). At the May house (1908), art glass represents the stems, leaves, and flowers of an unspecified plant. The Darwin Martin residence (1904) was the home of the Tree of Life windows. Strong linear lines appeared in other glass, whose multiple facets reflected light so that no curtains were needed for privacy in daylight.

The popularity of Wright's new designs spurred many designers to produce similar windows for other Prairie Style houses in the Midwest.

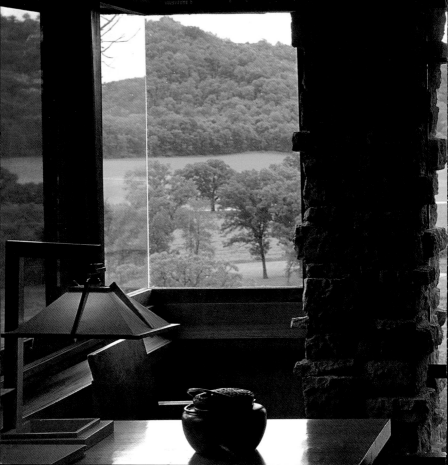

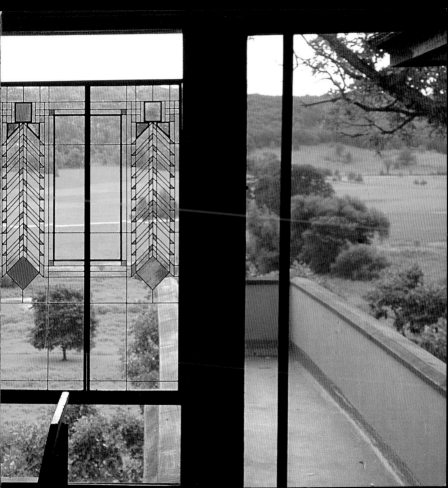

Installed next to the doorway to the birdwalk at Taliesin (1911–59), Spring Green, Wisconsin, is an art glass window (pages 28–29) from the Heath house (1904), Buffalo, New York. Clear glass doors and fixed panels draw the room into the treetops.

Although Wright's plans for the Hollyhock house (1917) in Hollywood (right) called for art glass in every window and skylight, most was never made.

Treelike glass abstractions for the Ennis house (1923) in Los Angeles (opposite) were among Wright's last use of his characteristic art glass.

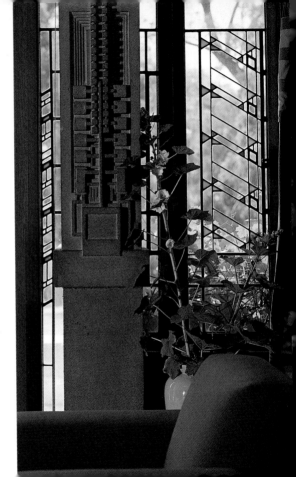

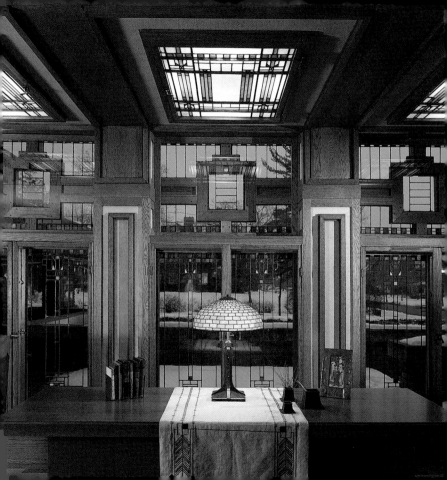

LIGHTING

ELECTRICITY AND SKYLIGHTS

JUST AS WRIGHT WAS BEGINNING his career, electricity was being introduced—offering unending design possibilities that he was eager to explore. Unlike gaslight, electric light could be safely concealed and directed. Hidden behind translucent glass, it could spread soft light from above like sunlight. It could be tucked above decks, reflecting light off the ceiling. Connected to freestanding or hanging lamps, it could bring light further into spaces. As Wright stated simply, "Glass and light—two forms of the same thing."

He buried light in chimney masses at the Bogk house (1916), Milwaukee. He attached lamps to dining tables for the Boynton (1908), Robie (1906), and May (1908) residences and to the sofa in the Hollyhock house (1917).

His art glass skylights were impressive for the feeling they introduced to a space. They generally were more complex than other glasswork, more colorful, and more abstract. Their role was to release a space without opening the view and to add a luminosity. The source of light, natural or artificial, was concealed, leaving a slightly mysterious feeling. It became one of Wright's many illusions.

> ⸙ Then too there is the lighting fixture—made a part of the building. No longer an appliance nor even an appurtenance, but really architecture. ...I can see limitless possibilities of beauty in this one feature of the use of glass. ⸙
>
> Frank Lloyd Wright
> "In the Cause of Architecture,"
> *Architectural Record*, 1928

With lighting, Wright's originality and versatility ran free—particularly during his Prairie Style period, when he combined lighting with exquisite art glass. At the May house in Grand Rapids, Michigan, the dramatic skylight was artificially lighted at night.

Compositions of glass cubes and spheres are suspended within Unity Temple (1904), Oak Park, Illinois, like extensions of Wright's childhood Froebel blocks.

Opposite, top: A skylight in the living room of the Heurtley house (1902), Oak Park, takes the shape of the roof. Tulip lights are clustered in the dining room of the Beachy house (1906), Oak Park. Bottom: A butterfly hanging fixture and a double-pedestal lamp in the Dana-Thomas house (1902) continue the show of glittering, filtered light that prevails there.

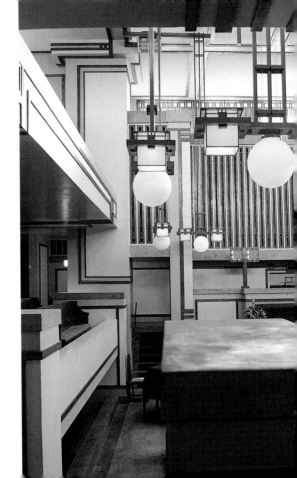

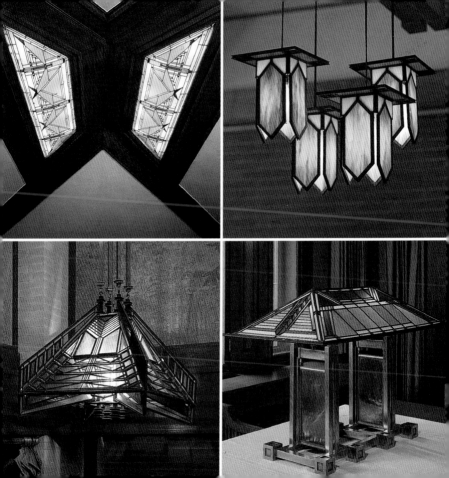

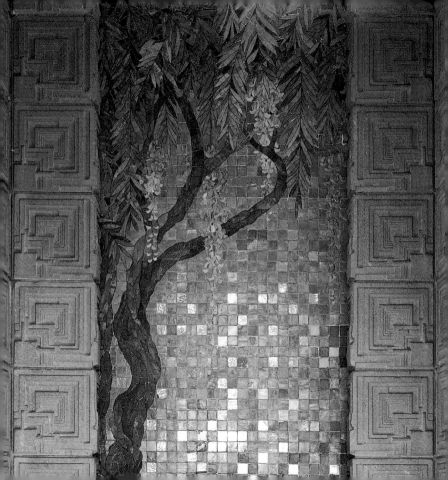

GLASS MOSAICS

TO LIGHT A FIREPLACE. 1899-1923

▓ What is this magical material, there but not seen if you are looking through it? You may look at it, too as a brilliance, catching reflections and giving back limpid light. ▓
Frank Lloyd Wright
"In the Cause of Architecture,"
Architectural Record, 1928

Three wisteria overmantels are believed to have been designed by Blanche Ostertag and executed by Orlando Giannini, Wright's trusted friend and artisan who executed some of his finest windows. Only the mosaic above the Ennis fireplace in Los Angeles survives.

THE DECORATIVE AND REFLECTIVE qualities of glass made it particularly useful in lightening the weight of a massive fireplace wall. Wright partially dissolved the solidity of the masonry in the May living room (1908) by placing slices of iridescent glass in the horizontal mortar joints—rows of brick floated above one another when light flowed through the southern windows.

Similar glass mosaics in wisteria patterns were installed on mantel facings for the Husser (1899, demolished), Darwin Martin (1904), and Ennis (1923) houses. They introduce a somewhat Japanese element to these interiors. Commissioned over a twenty-five-year period, the mosaics were placed in three completely different settings from coast to coast. The sparkling works combined colored opalescent and iridescent glass with metallic finishes in gold, bronze, and silver. How they must have glistened in sunlight or firelight!

In the Martin house, the flower mosaic was in the entrance hall at one end of a long pergola leading to real flowers in the conservatory. These elements, along with other decorative arts in the house, have been removed.

WINDOWS WITH WOODEN MUNTINS

SIMPLER SOLUTIONS. 1900-1959

Glass doors and windows in the Millard house (1923), known as La Miniatura, were divided into panes with wood muntins. The units matched the shape of the concrete textile block used in this Pasadena residence.

⚏ [W]e want glass to be the miracle life itself is. We will see, by means of it, the interior space come alive as the reality of every building. ⚏

Frank Lloyd Wright

"Building a Democracy"

Speech, 1946

THROUGHOUT HIS CAREER WRIGHT designed buildings with divided-pane windows that used wooden muntins much as he used metal bars in art glass. Why did Wright specify these simpler windows instead of his more customary art glass? They may have been chosen because of time constraints or the wishes and budgets of clients, or they may have been a design decision that suited the particular scale and grammar of the commission.

In the Beachy residence (1906), Oak Park, such windows were requested by the client, who feared that leaded glass was too fragile and not weather resistant. The house was large in scale and bold in its gabled forms and massing, well suited to heavier muntins.

At Auldbrass (1938), Yemassee, South Carolina, the angle of Spanish moss hanging from nearby live oak trees served as Wright's inspiration for the divisions in the glass. Living room windows of the Mossberg house (1948), South Bend, Indiana, also were separated by angled muntins that mirrored the rooflines. Glass in the entrance hall was divided in a bricklike pattern, unifying it with the masonry walls and surrounding floor.

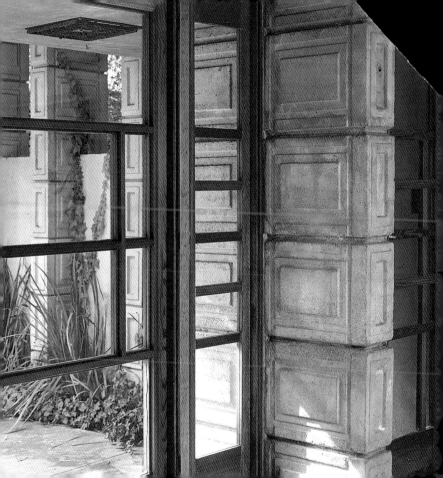

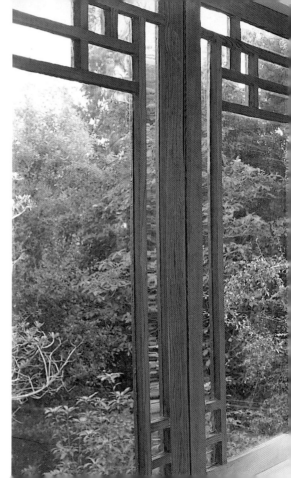

⊞ Glass alone, with no help from any of us, would eventually have destroyed classic architecture, root and branch. ⊞
Frank Lloyd Wright
Kahn Lectures, 1930

At the Prairie Style Stewart summer residence (1909), Montecito, California, divided panes in the windows, doors, and cabinetry recall the geometric designs Wright used in his art glass designs during this early period.

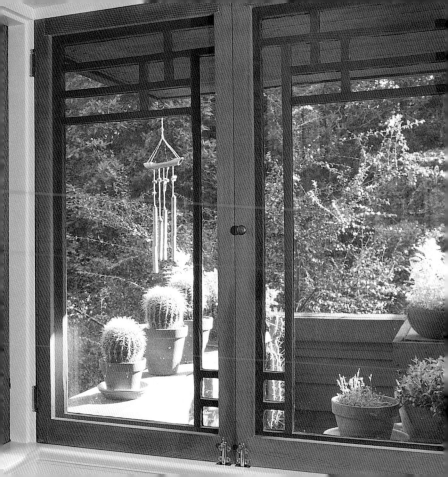

LUXFER PRISM GLASS

DECORATIVE MOLDED GLASS . 1894-97

IN 1897 WRIGHT WAS ASKED BY his friends and clients Edward Waller, W. H. Winslow, and William MacHarg to be a consultant to their new American Luxfer Prism Company. He had submitted an entry in their 1894 design competition for an office building using Luxfer prism glass but withdrew the design and served on the jury instead. His friend Robert Spencer won the prize, and Wright's building design was later published anonymously but never built.

Because electricity was so new, lighting was still a problem in city storefronts. Used in transoms, the prisms brought diffused light into the back of a store by bending the sun's rays, refracting them far into the space. Wright's Luxfer commission was to design these thin glass squares, which had decorative designs on one side and triangular prism ribs on the other. Once these units were electroglazed together using copper, they were air and water tight and could be mounted in sheets with the prism side toward the interior of a building. The income from this commission enabled Wright to add a studio to his Oak Park home.

Luxfer prisms were popular in buildings of the time but were never used in a Wright structure—even though he held the patent for fourteen prism light designs and twenty-six prism plates. Sullivanesque in appearance, they used flowerlike circles, ellipses, and squares.

⠿ Metal lines as narrow and accurate as if drawn with a ruling pen. Absolutely rigid without the use of unsightly iron braces. Our electroglazing process means a revolution in the manufacture of art leaded glass. ⠿
American Luxfer Prism Company ad, 1898

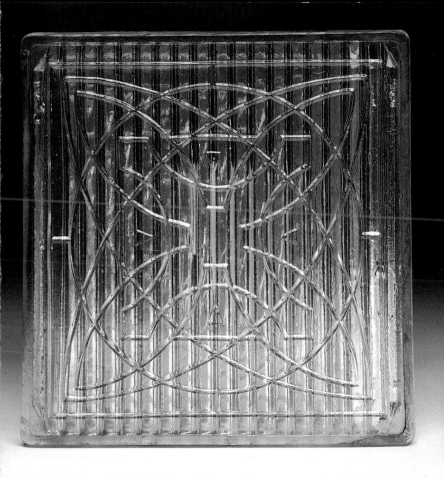

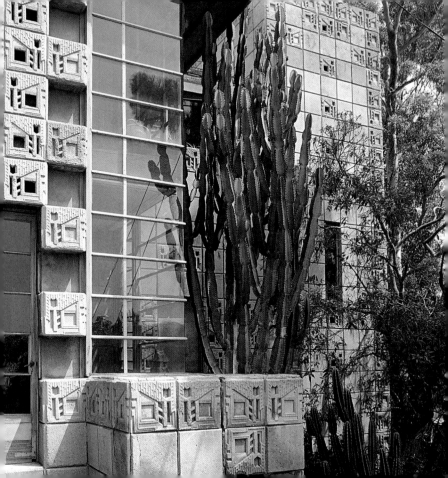

GLASS IN CONCRETE BLOCKS

THE NATURE OF CONCRETE—ITS PLASTICITY, earthiness, and durability—led Wright to create a building system he called textile blocks. Four houses were built with them in California in the 1920s. As he wove together the buildings with specially cast blocks and steel rods, Wright interwove glass as well. Each had a number of block designs to suit different needs, some of which were perforated to hold glass, thus sharpening the edges of the design. Some appeared to be giant Froebel structures with glass representing the voids between blocks—there and not there, seen and not seen. The solidity and texture of the earthen material were complemented by the lightness and smoothness of glass, as natural together as earth and sky. Textile blocks in the Freeman house (1923) meet the glass of the curtain wall directly, the glass continuing around the corner.

In the 1950s Wright resurrected a block system in his Usonian Automatic houses. Although simpler, their shapes provided more opportunity for glass to oppose and thus enhance the effects of concrete. In these imaginative buildings, Wright manipulated form to create space and space to create form.

Wright's glass innovations were often extensions of his structural developments— a stylistic partnership that grew from the nature of each design. At the cantilevered concrete Freeman house in Los Angeles, the inner solidity allowed the outer wall to be opened with glass.

⊞ Wright makes every axis terminate out of doors, in light, which again contrasts with the relative darkness of the interiors and draws people towards their destinations. ⊞

Jeffrey M. Chusid
"Frank Lloyd Wright's Textile Block System," *Concrete in California*, 1990

GLASS IN WOODEN PANELS

Perforated panels in Wright's Usonian residences such as the Pope-Leighey house (1939), Mount Vernon, Virginia, became stencils—working like branches in the woods to create light and shade.

DECORATIVE ORNAMENT IN WRIGHT'S Usonian houses was limited, simple, and integral to the structure. Clerestory windows, and sometimes other windows, in these moderately priced residences were partially covered by plywood panels perforated with a fret-sawn, geometric pattern that related to the house's motif. Light passing through the clear glass was shaped into interesting patterns inside.

Wright favored broken light from above and employed the technique frequently, beginning with wooden fretwork panels covering recessed lighting over the dining table and in the playroom in his Oak Park home. In the Coonley house (1907), Riverside, Illinois, they were extensions of the decorative wood banding on the ceiling. As geometric shadow makers, they added to the natural warmth and character of the spaces.

The patterns seemed to evolve from playful exercises at the drafting table. Repeated down a hallway or across a glass wall, the designs became a melodic chain. In a sense, these screens served as a transition between outside and inside—a dotted line.

⊞ The best way to light a house is God's way—the natural way, as nearly as possible in the daytime and at night as nearly like the day as may be, or better. ⊞
Frank Lloyd Wright
The Natural House, 1954

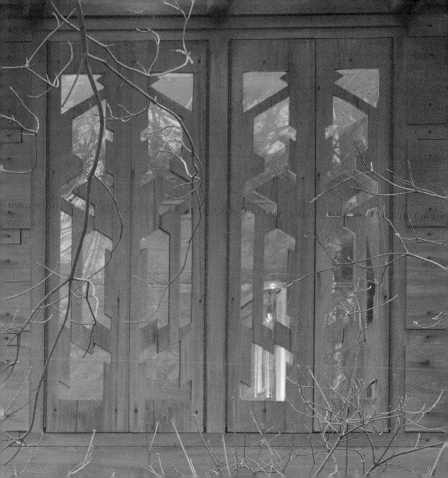

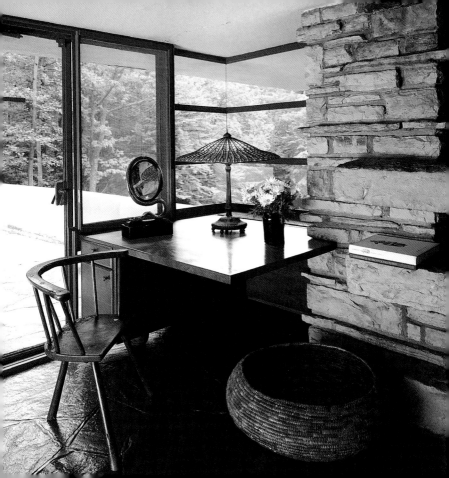

INVISIBLE JOINTS

At Fallingwater, the Kaufmanns' retreat in Mill Run, Pennsylvania, Wright created invisible corners that merge inside and outside. He also butted the glass directly into the stone—an innovation achieved at the suggestion of the client. Wright did not, however, disguise the metal window frames. Clearly expressed, they were painted red no less, to draw attention to their modular rhythm and to carry continuous lines as a foil for the jagged stone.

WRIGHT CONTINUED TO LOOK FOR techniques to help him decrease the confining boxiness of buildings. Beginning in the mid-1920s, he introduced more creative glazing techniques that virtually erased some window joints. In his own rebuilt Taliesin (1914) and commissions for the Freemans (1923) in Los Angeles and the Richard Lloyd Joneses (1929) in Tulsa, Oklahoma, he set pieces of glass at right angles with mitered joints. It thus appeared as if a single sheet of glass had turned the corner—or better yet, that there was no corner at all.

Wright experimented with various sealants. A transparent seal called water glass was used at Fallingwater (1935). He also scribed some glass directly into the stone and sealed it, without a wood or metal stop.

Such open construction was possible because of framing and structural advances that no longer required exterior walls to bear weight. The cantilever became yet another tool for Wright to pry open the box. Concrete shelves projected from a strong, structurally supportive core. Outside walls could then be free and open—made of cloth if desired—so long as they were weather tight.

TUBULAR GLASS

WRIGHT'S STREAMLINED DESIGN for the Johnson Wax Administration Building (1936) and Research Tower (1944) in Racine, Wisconsin—two of his most celebrated and innovative works—relied on a unique system of glass tubing instead of flat glass, completely dissolving architecture's boxlike confines.

Because of its industrial site, the first building was turned inward. Through glass tubes that replaced a traditional cornice on the low, squarish structure, sunlight filtered naturally onto the central work area below. Other tubes were installed on the roof, in spaces between distinctive concrete columns resembling lily pads.

Wright chose Pyrex glass tubing because it responded better to the rounded corners of his design and provided the durability, translucence, and profile he wanted. Four-foot lengths of glass were connected with two-inch coupler tubes and the rows joined together with mastic. The lines created by the joints between the tubes add to the horizontal look. Rows of glass that wrap around the tower partially dissolve the spaces between the floor slabs, revealing the structure's treelike form.

Buried between two layers of glass tubing were Lumiline bulbs, simulating translucent natural light at night.

▒ So rich that it appeared to have substance, the light seemed to be the matter of which the great room was made. ▒
Jonathan Lipman
Frank Lloyd Wright and the Johnson Wax Buildings, 1986

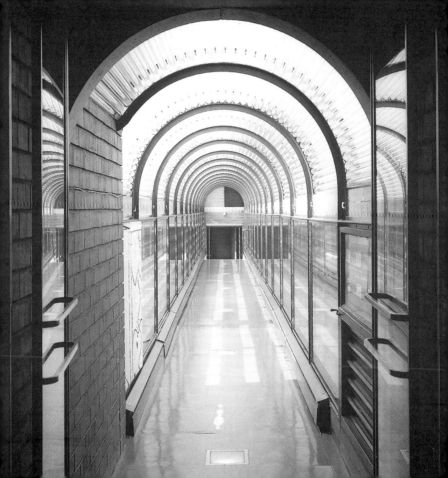

BROAD EXPANSES OF GLASS

▦ Glass can do as much for the small house as the large, perhaps more. It adds smart individual touches that mark your home as up to date . . . makes it a kind of place that will be a constant source of pride and satisfaction to all your family . . . a home that will win the admiration of all who see it. ▦ Libbey Owens Ford ad, 1946

At Cedar Rock (opposite), squares of insulated glass set into the concrete roof help invite in enough light for an indoor garden. For the second Jacobs house (pages 54–55), Wright produced a solar wall that warms this house in a northern climate.

GLASS ALWAYS PRESENTED WRIGHT with an opportunity for integral ornament. Huge, uninterrupted clear sheets, while rarely used, thus invited the natural world to provide free decoration. Each unit of glass, together with its shape and ornament, was calculated like a unit of masonry, concrete, or wood—one an important foil and companion for the other.

Wright's design for a glass house published in the July 1945 *Ladies' Home Journal* took form in the Walter house (1945), Quasqueton, Iowa, known as Cedar Rock. The square living area became a sunroom surrounded by a continuous band of windows in metal frames, with clerestory panels above. Although insulated glass was called for throughout, it was not sufficiently air tight, so one-fourth-inch plate glass was used. Mitered corners were sealed with a tree-sap compound that discolored and has been replaced with a clear silicone.

Wright's second Jacobs house (1944), Middleton, Wisconsin, beckoned the southern sun with a solar hemicycle rising two stories. Curved expanses of clear glass warmed the house on its private side.

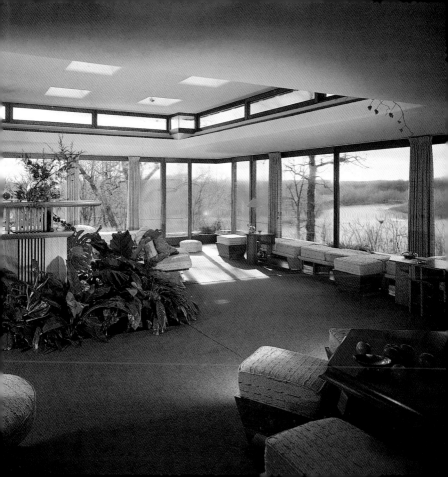

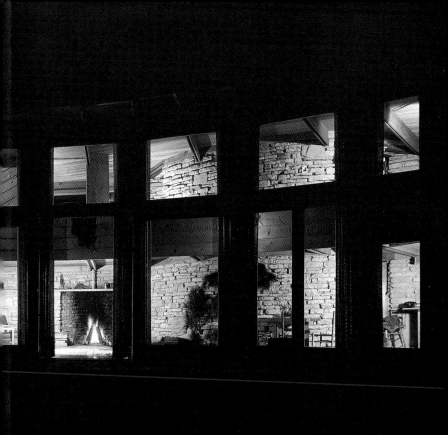

Hanks, David A. *The Decorative Designs of Frank Lloyd Wright.* New York: Dutton, 1979.

Hoffmann, Donald. *Frank Lloyd Wright: Architecture and Nature.* New York: Dover Publications, 1986.

Lind, Carla. *The Wright Style.* New York: Simon and Schuster, 1992.

Lipman, Jonathan. *Frank Lloyd Wright and the Johnson Wax Buildings.* New York: Rizzoli, 1986.

Manson, Grant Carpenter. *Frank Lloyd Wright to 1910: The First Golden Age.* New York: Van Nostrand Reinhold, 1958.

McCarter, Robert, ed. *Frank Lloyd Wright: A Primer on Architectural Principles.* New York: Princeton Architectural Press, 1991.

Pfeiffer, Bruce Brooks, ed. *Frank Lloyd Wright: Collected Writings.* Vol. 1: 1894–1930. New York: Rizzoli, 1992.

———. *Frank Lloyd Wright Monographs.* 12 vols. Tokyo: ADA Edita, 1987–88.

Riley, Terence, ed. *Frank Lloyd Wright Architect.* Museum of Modern Art. New York: Abrams, 1994.

The author wishes to thank Joanne Arms, Cedar Rock, Quasqueton, Iowa; Meg Klinkow, Frank Lloyd Wright Home and Studio Foundation Research Center; Roland Reisley; Charles Rubis, Oakbrook Esser; John Thorpe; John Tilton; Lynda Waggoner, Fallingwater; Virginia Wright, Corning Glass Museum; and especially the generous owners of the buildings included here. Special appreciation is due Gabriella and Uwe Freese, Mary and Lars Lofgren, and Dietrich Neumann for assistance with new photography.

Illustration Sources:

Ping Amranand: 47

Gordon Beall: 14 top left

© Judith Bromley: 13, 20, 21, 35 top left and right,; courtesy Dana-Thomas house: 14 bottom left, 26

Doug Carr, courtesy Dana-Thomas house: 2, 6–7, 17, 35 bottom left and right

© Farrell Grehan: 28–29

Biff Henrich: 11

Carol M. Highsmith: 43

Historic American Buildings Survey: 27, 50, 51

Balthazar Korab: 12, 14 top right, 32, 34

Christopher Little: 48

John Marshall, courtesy Jeffrey M. Chusid: 44

Metropolitan Museum of Art: 22 (67.231.1–.3)

Phil Mrozinski, Frank Lloyd Wright Home and Studio Foundation: 18

© Cervin Robinson: 24–25

Steelcase Inc., Grand Rapids, Mich.: 8

Ezra Stoller © Esto: 53, 54–55

Tim Street-Porter: 31, 36

University of California at Santa Barbara, Architectural Drawing Collection, University Art Museum: 1, back jacket

© Alex Vertikoff: 30

Scot Zimmerman: 14 bottom right, 39, 40–41